D0759862

Pg. 10

CÉZANNE
IN PROVENCE

First published in the United States of America in 1996
by UNIVERSE PUBLISHING
A Division of Rizzoli International Publications, Inc.
300 Park Avenue South
New York, NY 10010

and THE VENDOME PRESS

ISBN 0-7893-0059-1

Printed and bound in Italy

Library of Congress Catalog Card Number: 96-060376

UNIVERSE OF ART

CÉZANNE
IN PROVENCE

TEXT BY DENIS COUTAGNE

Director, Musée Granet, Aix-en-Provence

TRANSLATED AND EDITED BY DANIEL WHEELER

UNIVERSE/VENDOME

Foreword

One could become a poet merely by reeling
off the favorite sites of Paul Cézanne: Les Lauves, Château-Noir,
Bibémus, Sainte-Victoire, Jas de Bouffan.
The names became titles for the artist's paintings because, like
the pictures, they signify, in deep, resonating ways, the very color of
rocks, the power of the winds, the more or less malefic presence
of places. It was on the steep terrain of Les Lauves that
Cézanne built his outdoor studio; the Château-Noir is a strange,
neo-Gothic manor house erected in the early 19th century;
the Bibémus quarries yielded the ochre, crystalline stone that gives
Aix's 12th- and 13th-century houses their magical color.
As for Mont Sainte-Victoire, the Christian name
belies an older, secular tradition which held the mountain to
have been the site of Marius's victory over the Cimbrians
and Teutons in 101 BC, thus a geological symbol of order prevailing
over disorder. "Astonishing motif" was how the young Cézanne
characterized Mont Sainte-Victoire, well before he had any notion of
the impact the great tertiary mass would have on his art,
then already advanced beyond its clumsy beginnings into full-
blown Impressionism. Perhaps it was precisely
such contrasted and powerful sites the painter needed in order to
realize his ultimate maturity, and "make of Impressionism an art
solid and durable like the art of the museums."
Only rarely has an œuvre been so perfectly linked with a
landscape, even though Cézanne's paintings escaped
descriptive figuration to become an all-important pioneer of the
20th century's protean adventure.

Cézanne, the enigma . . .

after viewing the fifty-seven Cézannes at the Salon d'Automne of 1907, Rainer Maria Rilke wrote to his wife: "I know a few details of his last years, the time when he was old, shabbily dressed, and when children ran after him as he walked to his studio and pelted him with stones as if he were some stray dog..." The year before, when Cézanne died in seclusion near Aix-en-Provence, the clerk responsible for recording the death had cited the profession of the deceased as *rentier* ("person of independent means"). In other words, there was very little in the life of Paul Cézanne (1839-1906) to satisfy the novelist seeking to create literature out of the real or imaginary events attributed to him.

The only writer who ventured along this path was Émile Zola. The novel in question is entitled, suitably enough, *L'Oeuvre*. An absorbing work, rich in incident, it had the unfortunate effect of bringing an end to the long and close relationship between painter and writer: "I have just received the work you were good enough to send me," wrote Cézanne. "I thank the author of *Les Rougon-Macquart* for his kind token of remembrance, and I ask that he allow me to clasp his hand while reflecting on times past..." The letter is a subtle rebuke, for by acknowledging Zola as the author of the *Rougon-Macquart* novels, Cézanne sent him back to his own literary world, where he belonged, given his cluelessness about painting. In *L'Oeuvre* the character Claude Lantier is a failed painter who commits suicide in front of a canvas he cannot finish, a situation reinforcing the view that Zola was incapable of approaching art except from a sociological perspective. What, then, remained of a childhood friendship formed at the Collège Bourbon in Aix-en-Provence? Did Émile still remember the thirteen-year-old Paul, who had defended him against school-yard bullies? Had he completely forgotten the apples he once offered his protector? Theirs, after all, was a friendship forged in common struggle, in sharing, and in mutual regard.

Walks in the scrublands, nights under the glittering stars, bathing in the River Arc – such were the joys shared by Paul and Émile in the surge and glow of their adolescence. "Do you remember that pine tree on the verdant bank of the Arc with its shaggy head bent over the gulf yawning at its feet?" asked Cézanne in a letter to Zola dated 9 April 1858. "The pine tree whose foliage sheltered our bodies from the heat of the sun? Ah! May the gods protect it from the fearful blow of the wood-cutter's axe!" With a few books in tow (Musset, Vigny, Victor Hugo), the two friends sat on the water's edge and declaimed poetry, ordering the wind to echo the rhymes against the cliffs of Mont Sainte-Victoire. The pine would play a key role in several pictures – "the harmonious pine tree," as Cézanne called it in a letter of 15 January 1882 to Paul Alexis. Once again the master was by the river where he imagined his bathers among the trees.

This is not the place to explore the genesis of a pictorial œuvre based upon biography. However, we can, with the aid of a few examples, show how the Cézannean world – a world of apples, trees, nudes, rocks, mountains, houses – evolved from events, encounters, and experiences in the life of a young man, even though it may not be possible in every case to establish direct links between a known adventure and a specific canvas. Cézanne will always remain an enigma. Still, let us beam a few shafts of light not on a flesh-and-bone painter but, rather, on an artist who has long since become a figure of legend. We will try to lure him, like Quasimodo, from behind his big bells and catch a glimpse of his angry face. In brief, we hope finally to know what stuff Cézanne was made of and of what material his pictures are composed.

Van Gogh grips our souls, for the good reason that his passionate and tempestuous life seems fully present in the roiling impasto of his sun-flowers and Provençal skies, an existential drama that would have its dénouement in the suicidal gesture at Auvers-sur-Oise. Despair and madness. Gauguin touches us because of his headlong flight over the horizon, which meant abandoning his domestic, social, and even artistic world and acting on Baudelaire's *invitation au voyage*. Quite simply, he realized the dream of escaping far away, of daring to love *les merveilleux*

nuages, those "marvelous mists," to disappear physically from "Europe with its ancient parapets," all in the hope of being reborn under a tropical sun.

The lives of Van Gogh and Gauguin almost beg to be transformed into novels or even films, and indeed Van Gogh has captivated more than one director. Cézanne still awaits his *cinéaste*. Truth to tell, the Aix master was a rather boring character, and once beyond the turbulence and anguish of youth, he lived out his years in a state of almost unrelenting cheerlessness. In 1885 Cézanne did mention a failed love affair, but by the end of the next year he had settled down and married his model, Hortense Fiquet. Meanwhile, he had also reconciled with Cézanne *père*, who then died in October 1886, leaving his son forever free of financial concern.

t he grand passion of Paul Cézanne would always remain painting, together with the country around Aix. While staying at Talloire on Lake Annecy, he complained endlessly of being away from his native ground. On 23 July 1896 he wrote to Philippe Solari: "When you've been born there, that's it; nothing else will do." Nor could Paris suffice, as he confessed to his parents in a letter of 1874: "I would love to be working in the Midi where the views offer the painter so many opportunities." As the years rolled by, he sank his roots deeper and deeper into in the soil of his youth, often citing the beauty of the Provençal landscape. "I have an enormous affection for the contours of our countryside," was how he put it in a note to Joachim Gasquet dated 30 April 1896. What is remarkable about these epistolary fragments, concerning the wonders of Mont Sainte-Victoire or the sea at L'Estaque, is that they reflect the kind of exalted feeling more associated with a naturalist painter than with a modernist like Cézanne. Nevertheless, he wrote to Solari on 11 March 1885: "I'm going for a walk over the hills, where I can view gorgeous panoramic scenes." The Cézanne of the letters was not the Cézanne who painted. At least, the

one did not function on the same plane as the other. But given all this love of country, how reliable is the story about children hurling stones at the elderly painter? Here, we have only to remember how Émile Bernard found himself sternly rebuffed for his simple attempt to help the master when he stumbled on some rocks. In other words, no one dared lay a hand on Cézanne, because Cézanne could not bear to be touched.

a Cézanne novel would be of the *nouveau roman* type: restrained and structured, concerned with a small number of repeating events, all similar but different, rather like the painter's apples. Still, the artist has often inspired the word "heroic," not only because of his lofty ambition but also because of the discrepancy between his exceptional genius and the rather awkward, unyielding talent with which he had to cope. The glory of the consequent paintings is that they seem so manifestly to be the record of a great soul mortally engaged in winning dominion over his own conflicted nature, which, thanks to the dynamic complexities of the art, becomes an expansive trope for modern civilization striving to wrest order from the chaos of post-feudal existence. After participating in the first and third Impressionist exhibitions (1874, 1877), the shy, painfully insecure Cézanne retired to the Jas de Bouffan, his wealthy father's estate on the outskirts of Aix, there to paint in solitude and overcome the mockery of critics who long continued to think him a deluded primitive or a psychopath. And indeed some of the pictures he first showed appeared to justify such an assessment, in as much as they fairly seethed, in both image and facture, with frustrated sexual longing. Yet, for all their heavy, dark ineptitude, the canvases displayed formal distortions of a parallel and contrasting sort that, as the inevitable product of a unique aesthetic vision and its expressive needs, would mature into the hallmarks of Cézanne's most accomplished art.

The process began under the tutelage of the great Impressionist painter Camille Pissarro, who perceived his pupil's latent power and

helped the *sauvage raffiné* "with all his might to regulate his temperament and to impose upon it the control of cold conscience." Gradually, Cézanne came to depend less on his lurid imagination and more on the bright, external world of sight. Before a still life or landscape – a motif, as he called it, empty of human activity and thus free of all the disturbing associations such activity held for him – the artist could discover his own logic through the logic of nature and communicate it, not in imagery borrowed from religion, history, literature, or the contemporary social scene, but rather in the language of painting itself, in "plastic equivalents and colors." Cézanne then proceeded to "read," probe, and search the subject for the structuring abstractions he sensed within the variegated shapes, forms, and concretions of visible reality. Having thus dismantled and fragmented the scene, Cézanne could next "realize his sensations" in a "construction after nature" – the painting. And he did so by means of his recently mastered Impressionist color, using it, however, with all the force and drama he once poured into erotic fancy.

f or the sake of "something other than reality," Cézanne sought to evoke "flat depth" through all manner of innovative strategies, beginning with a steep view, which tilts the horizontal plane of a tabletop up, more congruent with the picture plane itself. But while the widened mouth of an elliptical bowl also makes the motif seem viewed from above, thus more "squared" with the painting surface, the apples in the foreground may be represented as if resting at eye level. Thwarted perspective continues in the handling of color, where plane after plane of juxtaposed and overlapped pigment structures the apples as dense, compact forms, albeit with segmentally stroked contours that, instead of containing, rupture. While this flattens the modulated volumes, it also allows them to "bleed" or "pass" into one another, thereby tethering fore and aft, surface and distance. To stress the plasticity of the picture as a whole, Cézanne often warped his drawing, as for a wine

bottle swelling, in "sympathy," towards a basket of apples, the formal, synthetic continuity of which counterbalances the discontinuity, from left to right, of the tabletop's front and back edges. Having upset nature's balance by factoring it through his own heightened sensibility, Cézanne invented formal irrationalities so as to reorganize the motif into pictorial logic of a superior kind. Thus, the final composition, while alive with tension, possesses a serene poise in which we feel the measured rhythms and solidity characteristic of all great classical painting.

While some have wished to locate the origin of Cézanne's apples in the fruit given him one day by his boyhood chum Zola, it is clear that the Aix master had many other things on his mind. "With Cézanne," as Rilke commented, "[the fruits] ceased even to be edibles, to such a degree have they become real things, and to such an extent does their obstinate presence render them indestructible." Formal research into the everyday objects in Cézanne's still lifes discloses that the pitchers are Arlésian and the commode is the one in his studio. Cézanne spoke of *études* or "studies," reminding us that the work involved in painting is sometimes similar to the work in music: Cézanne's apples or Bach's "well-tempered clavier."

The Bathers

the adjectives most applicable to the early Cézanne, without considering the nouns, should include: bearded, thickset, stubborn, solitary, taciturn, testy, and glum. Cézanne himself would very likely have preferred the vernacular term *coulliard*, which, loosely translated, means "ballsy." What this brings to mind is *The Abduction* (1867), a powerful work dominated at the center by a nude man bearing off a woman who is equally nude but also in a swoon. Her abandon is so complete she could actually be dead. In any event, the flesh is livid, and heavier than the gathering darkness, itself a thick and opaque presence. The only glimmer of light comes from the crepuscular glow on a

distant mountain, easily recognizable as Mont Sainte-Victoire, making the first perhaps of what would be many appearances in Cézanne's work. Towards this goal the man strides determinedly, without so much as a glance at the two young women bathing on the opposite bank. One of these faces the viewer in a brazen, suggestive manner. The other figure behaves modestly, turning away slightly and allowing the water to conceal her abdomen and breasts.

W hat the two women signify are the polarities that would reappear throughout Cézanne's œuvre, including the three final *Large Bathers*, all left partially unfinished. On the left of these big canvases is a group of relatively reserved or circumspect women, while the women on the right display opulent thighs and breasts. Taken together, the scene proves that the artist never ceased to be gripped by his "phantasms," those dichotomies of provocation and withdrawal, of carnal aggression and timid retreat.

The conflict is already very much present in *The Abduction*. From 1866 until 1906, the year of his death, Cézanne never lost the passion that had racked him from the start. Even so, there is a fundamental difference between *The Abduction* and the *Large Bathers* pictures. In the former, the hero (Cézanne?) marches towards his destiny, clutching the cadaverous body of a woman too muscular to be beautiful, a woman oblivious to the bather who appears to entice the man from the opposite bank. Cézanne sets off on his journey, freighted with a terrible burden. Who is this woman with the waxy, leaden body, a dead weight the hero must carry with the goal of setting it down on the far-off mountain? The weight of academicism, the weight of sin, of painting itself, represented in the form of a woman? Whatever the answer, Cézanne conceived of painting, his painting, as something holy, a sacred vocation. "Could it be that Art is indeed a priesthood which demands that one belong to it wholly?" Cézanne asked in a letter to his dealer, Ambroise Vollard, on 9 January 1903.

In the last *Large Bathers*, Cézanne inevitably continued to pose the same questions, but now all has become limpid, especially the women, their bodies transparent, open to the wind, the sun, the freshness of the leaves. If the poses reflect the survival of old anxieties, the freedom with which the artist worked reveals him to have passed beyond sexuality. Gone are the opacity and heaviness of old. Even the thickest paint signifies transparency. Cézanne has at last reached the mountain, down whose slope water courses as if from the Fountain of Youth for an external baptism. Painting as catharsis has revived the woman and, in the process, allowed her to escape carnal grossness.

The theme of the *Large Bathers* is ineluctably associated with that of the Sainte-Victoire pictures, and it is no mere accident that the famous mountain can be glimpsed in one or another of the late Bather compositions. In these works, the woman is no longer a nymph or a goddess; she is simply a "bather," a body whose nudity partakes of the water and the sun in a clearing shot through with the colors of Provence, far removed from all Renoir sensuality or Courbet eroticism. Cézanne's bather becomes the sun, she becomes the water, she becomes both tree and mountain, because, finally, she has become painting, and painting has become light.

The Road

Cézanne was a man of the earth who loved hiking over the landscape. As a schoolboy, he, together with Zola and Jean-Baptiste Baille, wandered through every garrigue around Aix, especially the fields and thickets leading towards Mont Sainte-Victoire, which he climbed on several occasions. Once, having missed the carriage back to the Jas de Bouffan, the adult Cézanne set out and walked the thirty-odd kilometers from L'Estaque to Aix. He dared not let his father suspect the little son born of a liaison with Hortense Fiquet, and

his absence at the family dinner table would have confirmed the worst. For Cézanne, painting itself was a countryside to explore. It can hardly surprise, therefore, that the artist painted relatively few pictures of roads or paths. And where byways do appear they are always empty, with never a stage coach of the sort naturalist painters often included, or any dust to suggest the heat of travel. Nonetheless, Cézanne's roads are rendered with power and realism, since the artist always took note of embankments, ruts, and coarse gravel. The road is difficult, never presented as a royal highway. Obstacles impede our progress. Sometimes the path leads us deep into a forest, rendered like the center of a stained-glass window. Even more remarkably, an innocuous detail may become a path through the woods.

"One can find one's own little path, even though a soldier," so wrote Cézanne, on 27 February 1864, to Numa Coste, a young painter who had just drawn an unlucky number in the military draft lottery. The road becomes an invitation to return home in painting. Once accepted by Cézanne, Baudelaire's *invitation au voyage* led only to a space, that of painting, and for the Aix master, the land of his childhood harbored enough riches to satisfy his every requirement in matters of both drawing and color. This was true although the land so defined was very limited, even for the country around Aix. When at Gardanne, for instance, Cézanne never visited L'Isle-sur-la-Sorgue, the Palace of the Popes in Avignon, or Sainte-Baume. And did he go even once to Vauvenargues, Puyloubier, or Trets? The journey mapped out by Cézanne makes its way to Mont Sainte-Victoire, and from there to a "painting territory" that cannot be reduced to a known landscape, as the pictures in Cleveland and St. Petersburg demonstrate. Cézanne's oeuvre does not offer "things" to look at; rather, it celebrates and takes possession of a place, penetrating its mystery and relating its tragedy in the face of the gods. A rock, a millstone, a tree will suffice, but so will the body of a woman.

The Jas de Bouffan

t he Jas de Bouffan should be our starting point, the place where Cézanne most often lived when he was in Aix, at least until 1898, the year his mother died. Thereafter he never returned, so profoundly had Mme Cézanne become identified with the old country house, a former residence of the Governor of Provence. A year later the family sold the property, which Cézanne's father, Louis-Auguste, had acquired in 1859. Thus, it was at the Jas de Bouffan that Cézanne began to paint. Needless to say, the social ascent of the Cézannes, with its Balzacian dimension, annoyed the local aristocracy. This does not, however, explain Aix's rejection of Paul as a painter, since it was, after all, Cézanne *père*, the banker, who initially offered the main resistance to his son's artistic ambitions. But hardly had the family moved into the Jas when the twenty-year-old Paul took over a large room, the more or less abandoned salon on the ground floor, and turned it into a makeshift studio. Here Cézanne composed his first pictures, among them the *Four Seasons*, a suite of canvases whose clumsiness gave little hint of their creator's genius. Is this why the apprentice master angrily signed the works "Ingres," as an act of derision or mockery directed at the most celebrated painter then represented in the local museum? Furthermore, how is one to explain the evident act of filial devotion wherein Cézanne placed at the center of the Seasons – all female personifications – a portrait of his father, seated like a god reading his newspaper? To answer, one must recall what grief the young Cézanne had been obliged to endure before gaining paternal support for his desire to become a painter and move to Paris.

> *Not without fear does the banker Cézanne see*
> *Behind his counter a painter coming to be...*

Whatever the conflict between Cézanne and his father, the Jas de Bouffan would always remain a primary reference for the artist; indeed,

the pictures representing the estate (or such nearby sites as Bellevue and Montbriand) constitute the very heart of Cézanne's oeuvre. Themes include the *allée* or driveway lined with chestnut trees, the garden, the fountain, the house and the farm, the woods, the railway cutting along the edge of the property. It was also from the Jas that Cézanne first painted Mont Sainte-Victoire (the version now in Minneapolis), which in 1885 launched one of his most magisterial series.

Here as well Cézanne painted many still lifes, his Cardplayers and Harlequins, several portraits of his wife, and a number of self-portraits, in addition to a good many other portraits, such as those of Uncle Dominique, Joachim Gasquet, and Antony Valabrègue. And it was to the Jas that he returned every day while he was painting near Gardanne. In 1889 Cézanne had a studio built in the attic atop the Jas facing north. In such a tiny room the still-life motifs very likely had to be arranged in a way that forced the painter to view them from above. The *passage* or elision of planes, it would appear, arose from physical constraints before ever it became a "theory."

Bibémus Quarry and Château-Noir

Cézanne "went up" to Paris in 1861 and returned home the same year. He would, of course, be back in the French capital, but more than any other member of the Impressionist generation, he remained close to his roots, spending forty-six of his sixty-six years in Aix, if one counts all the months of his sojourns. A painter of landscapes, houses, and villages (Auvers-sur-Oise, Pontoise, etc.), Cézanne never once set up his easel on the Cours Mirabeau, near Aix's city hall, or in the Mazarin Quarter. Whenever he addressed his native city in art he focused on the Jas de Bouffan and his studio in Les Lauves.

As for Aix, the pre-Revolutionary capital of Provence, dozing under the shade of plane trees, Cézanne found no room for it in his art.

Nevertheless, he loved his home town. How, then, can Aix-en-Provence be called the city of Cézanne, given that the artist never painted its narrow streets, town houses, or fountains? Cézanne, of course, might insist that he did paint the city, although not the antiquated façades or the lively lanes crowded with coffee vendors. Cézanne was a man of foundations. Aix inside the old walls did not interest him, because here he saw only a stage set for opera. Cézanne sought the beginning and the end of things; thus, he went down into the city's nether regions, just as Jean Giono's hussard disappeared across the rooftops of Manosque. At once foundation and foliage, rocks and trees, wind and earth, interiority and exteriority – the Aix discovered by Cézanne lay between the Zola Dam and the city itself. This was the Bibémus quarry.

no other site better exemplifies what Cézanne meant when he wrote to Émile Bernard on 23 October 1905: "I'm striving to realize that part of nature which, falling under our eyes, yields up the picture to us." Cézanne painted more than twenty canvases with Bibémus or something similar, such as trees together with rocks, as their theme. Only once, however, did he mention Bibémus, a place he found by going up behind the Château-Noir or behind the Jesuit chapel near Le Tholonet. The citation came in a letter to Philippe Solari, written at the end of August 1897: "If you come in the morning, you will find me around 8 o'clock near the quarry, where you made a sketch when you came the time before last." But not a word about the fascination such a site could have for the painter. Still, more than any other favorite locale, Bibémus, with its natural grandeur, is the physical counterpart of Cézanne's painting.

Today, walking through the Bibémus quarry is tantamount to exploring Cézanne's pictorial space while also plunging into the heart of the town, a town born entirely out of its quarries. Here can be found the magic of the colored tonalities which endow King René's city with the charm that captivated none other than Mozart. At Bibémus, moreover,

nothing has changed, apart from the vegetation, if even that. The trees, particularly the pines singing in the wind, have grown taller above the cliffs, which are still bright ochre, especially when the setting sun is low enough to cast shadows from the chestnut foliage and pine boughs, creating a sumptuous spectacle of sound and light. At Bibémus the world surges up as on the first day of Creation. Its tones modulate into rose and purple, yellow and violet, indistinct yet differentiated as if the entire chromatic scale first came to life there. The foundation of the city corresponds to the foundation of color! Painting is therefore not so much on the artist's canvas as on rock faces whose veins and streaks capture the sun's color-filled rays.

*a*bove, there is the incredible sky, returned by the mistral to its primordial state – cobalt blue, phtalocyanine blue, ultramarine blue. No mixture of palette colors could ever yield the purity, power, and materiality of a sky as intense as the one over the quarries, or the sea at L'Estaque, which Cézanne painted it as if it were hard flagstone. But the Mediterranean at L'Estaque and the sky over Bibémus are forever buffeted by a mistral whose blasts structure and solidify their fragility. The resulting mineral quality of sky and water is what Cézanne transposed onto his canvas, while, paradoxically, he also endowed the rocks with both transparency and luminosity. "Nature, for us men," wrote Cézanne to Bernard on 15 April 1904, "consists more of depth than of surface, whence the need to include in our vibrations of light, represented with reds and yellows, enough shades of blue to create a sense of air."

Cézanne's painting therefore effected a transmutation of the visible world, the purpose of which was not to establish a new system of representation (a task he would leave to the Fauves and the Cubists), or even less to move beyond that world towards lyrical, metaphysical, or formal abstraction (which he left to the Kandinskys, Malevichs, and Mondrians of the 20th century). Rather, it sought to capture nature's infinite com-

plexity and richness. But nature, refusing to be caught, always escaped. "Nature presents me with the greatest difficulties," Cézanne confessed to Zola on 24 September 1879. Fortunately, the artist possessed a remarkable capacity for analysis and synthesis, which meant that he could function both as a receptacle for "sensations of color" and as a source of "theory." To define his art, he spoke more readily of *études* or "studies," of "realization," because the work of art he favored was something that came into being in parallel with nature, as a kind of second nature. Always in this encounter between painter and nature, the pictorial work asserted itself as an equivalent. "A rival," André Malraux would have said. Even a small fragment of the work sufficed to permit Paul Cézanne to test his intuition, a modest step perhaps but audacious enough that it brought him close to God. The painter, in his Aristotelian application of "mimesis," completes what remains incomplete in nature. Yet the nature of painting corresponds to the incompleteness of nature! This illuminates another of Cézanne's enigmatic sentences: "Light does not exist in painting." By this the artist meant light as flux, bathing things and revealing their silhouettes or forms. Cézanne's oeuvre, therefore, consists in giving visible things their invisibility, in allowing the passage of one order into another.

this passage assumed physical meaning once Cézanne chose Bibémus as a surrogate for Aix-en-Provence, since the quarries are to the city what the treasury is to the cathedral — a place of remains and relics, of indecipherable archives that are nonetheless the foundation of all things. Nicolas Poussin painted the ruins of ancient Rome. It follows, therefore, that Paul Cézanne, at a certain moment, would choose the Bibémus quarries, themselves ruins, in order to achieve the transmutation whose witness his œuvre became. Meanwhile, the quarries already constitute a universe where the transmutation of the world occurs quite naturally. Here nature becomes a city, even as the city becomes nature all over again.

Mont Sainte-Victoire

for Cézanne, Mont Sainte-Victoire was the prime focal point in Provence, to such a degree that its characteristic silhouette is known the world over, thanks to paintings hung in museums everywhere from Zurich, Basel, Edinburgh, and London to New York, Washington, Philadelphia, and Cleveland, Tokyo, Moscow, and St. Petersburg.

Yet, apart from the canvases entitled *The Abduction* (1867) and *The Railway Cutting* (1870), Cézanne did not take pictorial account of Mont Sainte-Victoire until 1885-1886, by which time he was already a mature artist who had been painting since his early twenties. Needless to say, he was not unaware that this massif, whose proud aspect had long symbolized the primacy of Roman order over barbarian disorder, served also as the signature of the *pays* around Aix. Well before he painted it, Cézanne had written about the natural landmark, doing so, for instance, in a letter to Zola dated 14 April 1878: "As the railway passed near Alexis's field, an astonishing motif surges up towards the east: Sainte-Victoire and the cliffs overlooking Beaureceuil. I said: what a fine subject"? But once he began painting the mountain, Cézanne would never give it up, even continuing to work through a rainstorm near Les Lauves, until he collapsed, the brush still in his hand. He was almost dead by the time a laundryman came along and helped him return home. This was in October 1906. Cézanne died during the night of the 22nd and the 23rd.

Fate allowed Cézanne not only a death which sealed the whole of his oeuvre but also an end that expressed its meaning. Picked up and placed on a wagon filled with canvases, he slowly expired in the midst of supports for his pictorial enterprise, thereby prefiguring the anxieties of a century in which painters would carry their interrogation of the material to the very stretchers and canvas of painting itself. Cézanne

knew supreme victory even as death finally came knocking. A holy victory, at least for those who endow the event with a sacred dimension. Had he not, after all, risked everything in order to paint "a fine subject"? Many others besides Cézanne, beginning with Constantin, Granet, and Loubon, have revealed the lines and gleams cast by a setting sun on the great tertiary rock. Cézanne, however, faced the mountain and confronted it absolutely. At first, moreover, his Sainte-Victoire pictures show the mountain as distant, inaccessible. Where roadways meander towards it, they soon peter out, disappearing behind a ridge or becoming lost in the fields. Elsewhere, a black tree surges up like a fist at the center of the picture, causing the mountain to appear martyred despite the light radiating through its mass. Viewed from the Ermitage, Mont Sainte-Victoire looks battered and abused, its scars conveying a sense of tragedy. Cézanne wants to approach, only to be blocked by a distant bridge, a row of trees, or a clump of bushes, all the most commonplace features imaginable.

The mountain, nonetheless, makes its presence felt, invading the whole of the pictorial field and contrasting with the artist's palette of soft, almost pastel colors. Gradually Cézanne gave up green, which, in his first versions of the Sainte-Victoire motif, had evoked the beauty of a Provençal spring. Later he would shift towards yellow or gray tonalities more in keeping with winter. Now the mountain seemed almost appropriated, its image grown serene and luminous. Then came the last works. Following the death of his mother and the sale of the Jas de Bouffan, Cézanne had a studio built on the slopes of Les Lauves, just outside Aix, beyond the cathedral. Thereafter he would rarely paint Mont Sainte-Victoire from any other vantage point, the hillside where the mountain loomed before the artist like a spur of light or night, thick yet translucent.

Cézanne simplified his composition to the extreme, no longer attempting, through careful drawing, to render the geological folds and shifting terrain, the trees and houses on the plain stretching out between himself and his grand motif. He concentrated, with all his might, on painting exclusively with color, utilizing such devices as

contouring, multiple plane-like strokes, contrasts of warm and cool tones, harmonies, and complementary hues. The result is symphonic, simplicity matched only by its own richness, prompting some critics to compare Cézanne to the great Venetians of the 16th century. "I proceed very slowly, since nature appears to me very complex," the elderly master wrote to young Bernard on 12 May 1904. Sighting locally from a multiplicity of angles and nurturing his smallest sensations of the motif, frequently over a long duration, Cézanne might have lost command of his picture except for the fact that he made sure to "advance all of the canvas at one time." Thus, no work by Cézanne, including those scarcely begun, ever seems unfinished. Even the white, the bare support, will have been so sensitively deliberated that it contributes to the total effect no less than the colors.

In the Mont Sainte-Victoire pictures, the subject is simultaneously both present and absent, luminous and somber, sky and earth. Here Cézanne synthesized not only the whole of his oeuvre but also the whole of Western painting, summarizing a long figurative tradition while also anticipating the tradition to which he would give birth. "I work doggedly on; I glimpse the Promised Land," he wrote to Vollard on 9 January 1903. "Shall I be like the great leader of the Hebrews, or shall I be able to enter it?"

Les Lauves

In 1901, Cézanne acquired a half-hectare of land "astride Les Lauves" on the edge of the Verdon Canal. Here, he built what was less a studio than a light-filled space of the kind his painting demanded. He also had it designed big enough to accommodate the most monumental of his pictures, which at this time would be the *Large Bathers*. A slit in the wall, measuring about 40 centimeters wide, allowed for the passage of stretched canvases too large to be brought in or removed by the stairs. Everything in the studio was there solely

because of its relevance to the artist's work: several pieces of furniture, skulls, pots, a tall ladder, the easel, and a few engravings reflecting certain longtime interests.

by now Cézanne had begun to receive a growing number of visitors: Maurice Denis, Ambroise Vollard, Émile Bernard, Raymond Roussel. Henri Matisse would wait too long, while Georges Braque arrived in L'Estaque sometime during October 1906, too late to meet Cézanne, who died that month, just when his ten canvases in the current Salon d'Automne were proving a magnet for a new generation of artists. Everything in the studio speaks the language of Cézanne, in a hushed, secret voice. Here one automatically stands in silent respect before the opening towards Aix. All about, the walls condense light to its essence, a somewhat abstract light circulating in a space marked by extreme geometric clarity. In this space Cézanne concentrated exclusively on the Mont Sainte-Victoire pictures, the *Large Bathers*, the still lifes with skulls, or apples, or plaster casts, the last reflecting the artist's steadfast devotion to such earlier masters as Puget and Michelangelo.

In the course of that last summer in 1906, Cézanne divided his time between work in the studio and studies from nature. Certainly he would not restrict himself to the atelier while carrying out his investigation of Mont Sainte-Victoire. He still made frequent visits to the River Arc, where the relative coolness of the temperature provided relief from what was an exceptionally heavy summer. Paul Cézanne was diabetic, and the hot, sultry weather of dog days made his life almost intolerable. Letters to his son bear witness to that suffering and tell us something of the trial his last months became: "The weather remains stifling; I'm waiting for the car to take me to the river," Cézanne wrote on 2 September 1906. Again on the 8th, he commented: "A new heat wave. The air is oven-hot, no trace of a breeze." This was followed on the 13th with: "Because

of fatigue and constipation, I've had to stop going upstairs to the studio." Then on 21 September he confessed: "My mind is in a terrible state, full of troubles."

Cézanne, nevertheless, went on with his portrait of the gardener Vallier. "I still see Vallier, but I am so slow in my realization...," he wrote to his son on 28 September. The portrait that comes down to us tells of approaching death. Here Cézanne achieved a psychological intensity matched perhaps only by Rembrandt. The subject is withdrawn deep into his own agedness. No outside drama could possibly disturb him, for his life, burdened by the weight of an entire existence, is sufficient drama unto itself. And so, Cézanne, in his studio, struggles with this portrait in the hope of expressing the lassitude of a man, the lassitude of mankind. But also at work in the painting is a strange power, a power that endows a tired body with gravity, a gravity which suddenly becomes light.

Will I reach the goal so long sought?

Is there anyone who has not heard this question put by Cézanne in 1903. Is there a critic or art historian anywhere who has not offered a response? Privileged by hindsight, we have only to consider the experience of Georges Braque at L'Estaque in 1908 following his abandonment of Fauvism. The works he produced during this sojourn on the Bay of Marseilles are not only Cézannesque but also proto-Cubist, or even fully Cubist, which positioned Braque, in the modernist project, ahead of Picasso, who was still involved with the formal problems of depicting women. Given this history, we could well speculate that Cubism was where Paul Cézanne would have arrived if...

Meanwhile, Kandinsky would have us note the "triangle form" in the structure of the *Large Bathers* and see it as nothing less than an anticipation of the abstract language that would emerge in response to an

interior need transformed into a principle of necessity. Now one may view Cézanne as the forerunner of almost every kind of abstraction – the lyrical abstraction exemplified by Kandinsky, the formal abstraction of Mondrian, and even the metaphysical abstraction of Malevich. Cézanne, in certain of his statements, appears to corroborate such reasoning. From a letter written to Émile Bernard on 23 October 1905, we have the following: "The sensations of color that produce the light yield abstractions that do not allow me to cover my canvas." And to support the case for a pre-Cubist Cézanne, we have only to consider an even more famous line, again addressed to Bernard, this time on 15 April 1904: "See in nature the cylinder, the sphere, and the cone, putting everything in proper perspective." Cézanne seemed already to understand how the history of painting would unfold in the early 20th century.

many are the art historians who have attempted to answer the question cited above. The answers, however, prove less interesting than the question. What is certain is that by 1906 one innovative, modernist development after another would be claiming derivation from the Aix master. Whereas Cézanne's emancipated color meant everything to Matisse, Picasso and Braque ignored that element to develop a new pictorial unity out of the underlying geometries Cézanne had counseled Bernard to seek in nature. In his uniform faceting of objects and space, his shallow depths and structural armatures, his simultaneity of vision, and the *passage* his broken contours made possible from plane to plane of distinct and separate objects, Cézanne blazed a trail that led Braque and Picasso to Cubism in 1908-1909. Thus, while always faithful to recognizable subject matter, Cézanne's painting nevertheless served as a transition between an older, 19th-century, perceptual art and the pure, geometrically abstract, or nonrepresentational, art of the 20th century. The artist himself declared that he was no more than "the primitive of a new art," of a "vision" he had failed to realize in all its implications. Others have

likened him to Giotto, the late-medieval master who initiated the idealized realism that culminated in the Renaissance and Baroque styles, an illusionistic, or *trompe-l'œil*, mode of expression that continued to dominate Western art until overthrown by the modernism launched by Cézanne. The comparison is apt, for Cézanne too produced an art of clarity and calm by bringing into dynamic equilibrium a whole array of warring factors: orderly form and wild nature, the immutable and the momentary, color and line, surface and depth, and, not least, his own personal conflicts, among them a conservative, Provençal background and unruly, bohemian tendencies, a classical education and romantic, even violently emotional drives. Yet, for all his paramount importance, Cézanne never ceased to question the very meaning of his work. He did not fear death for himself but merely for his work, that it might be left unfinished (an obsession shared by Marcel Proust), that he might not be allowed one day to enter the Promised Land.

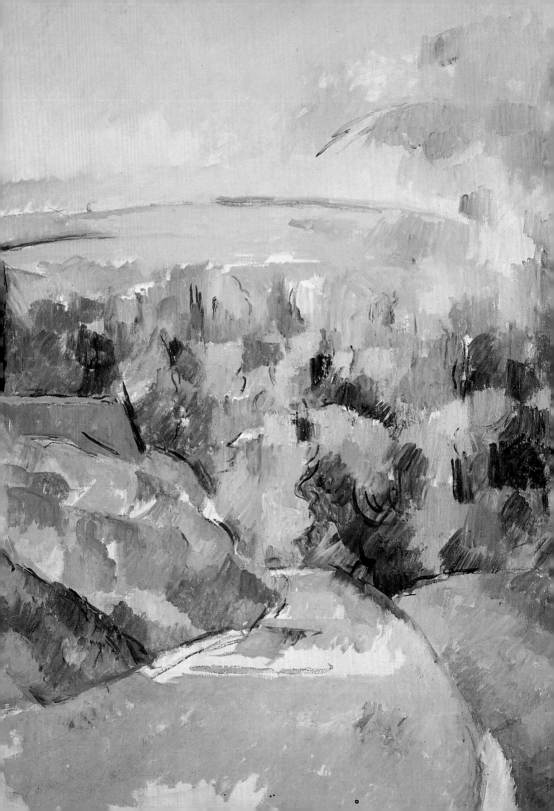

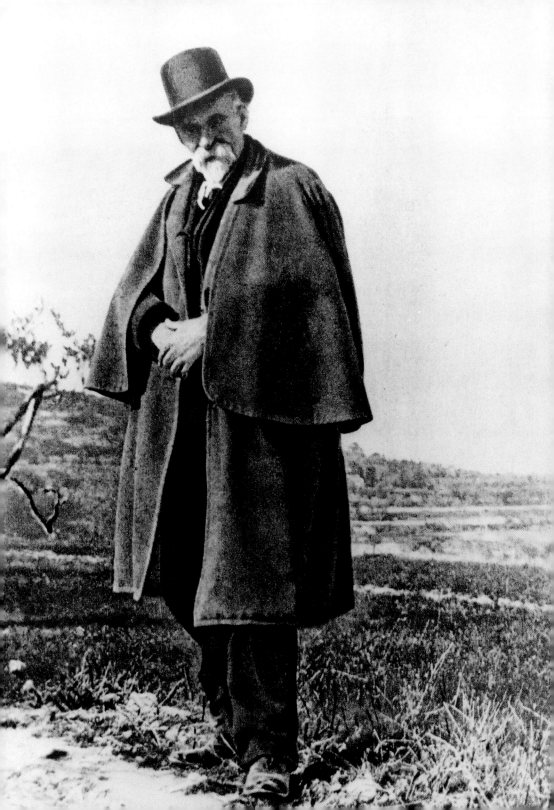

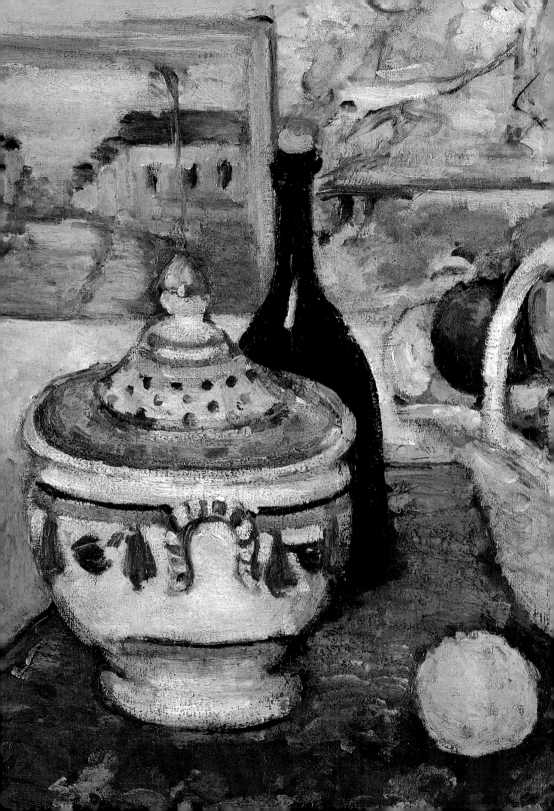

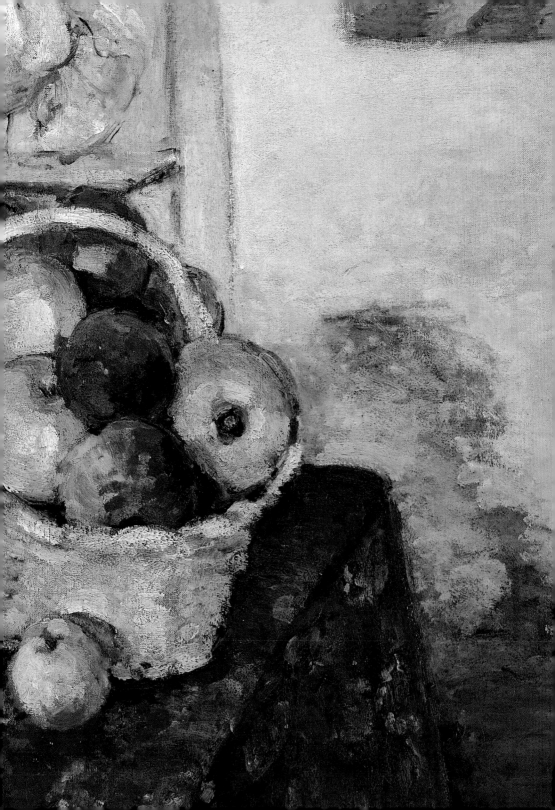

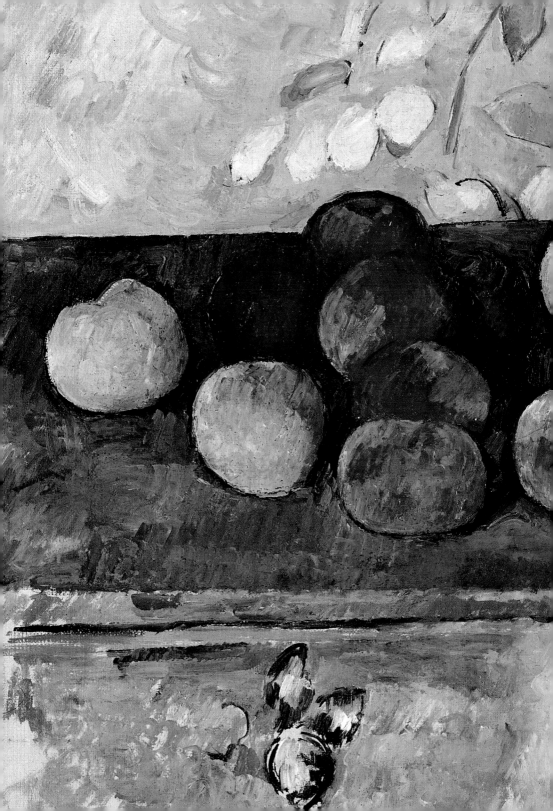

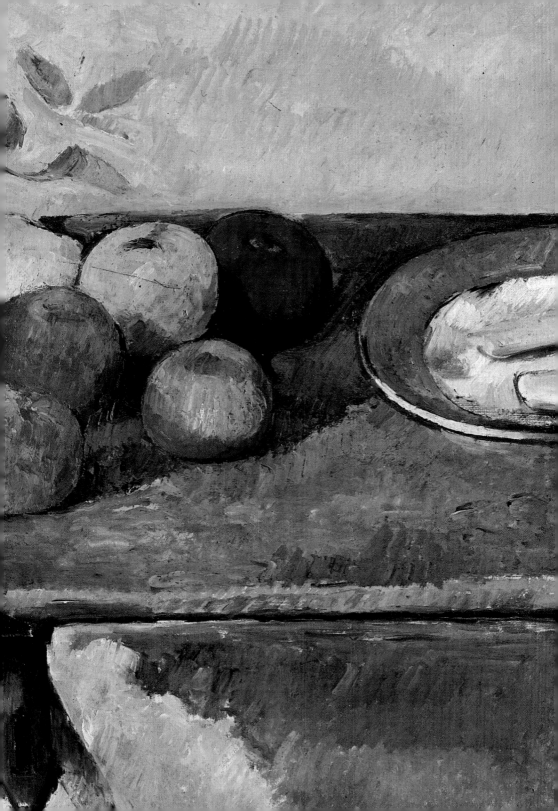

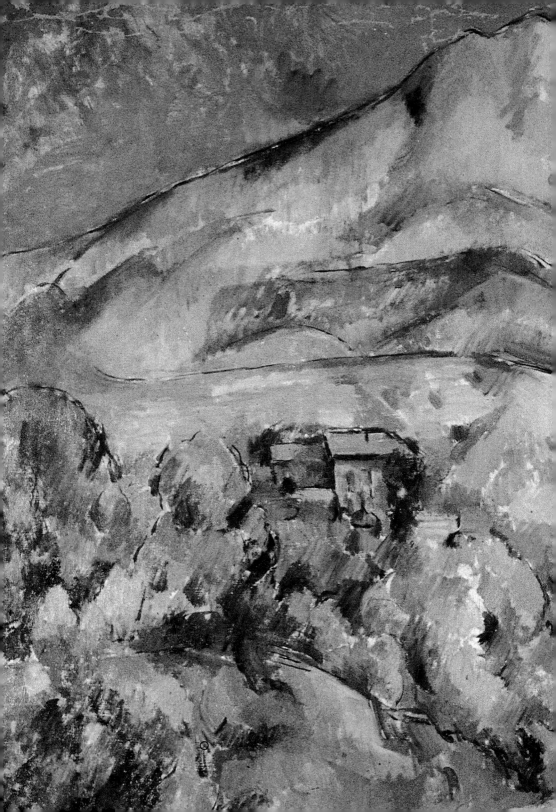

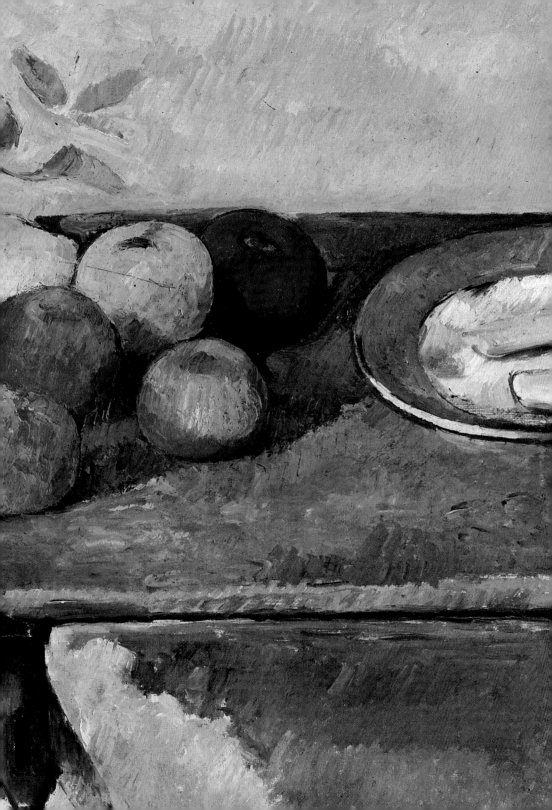

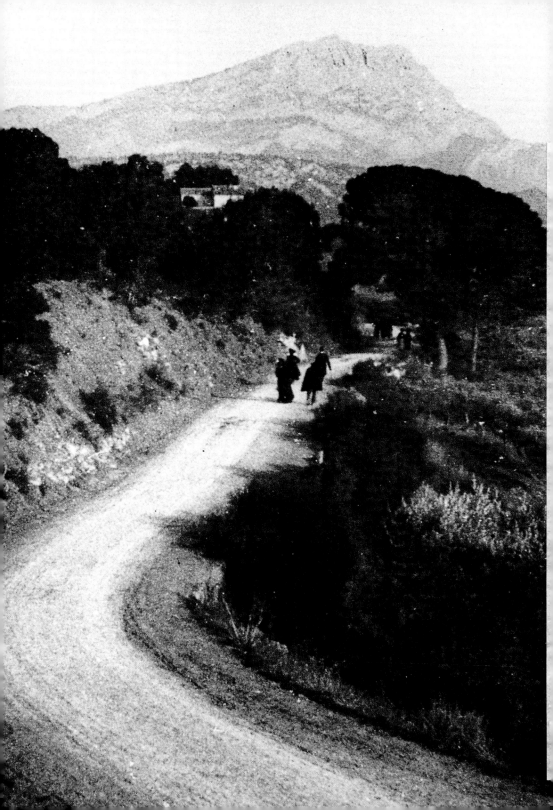

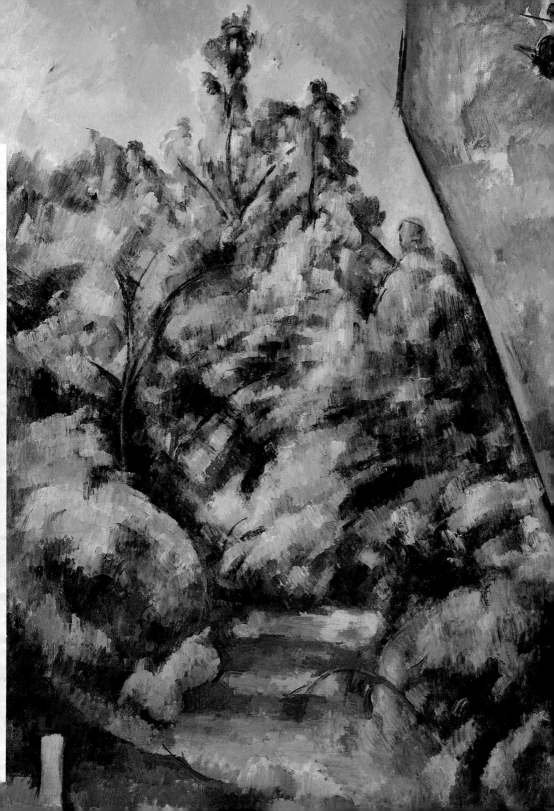

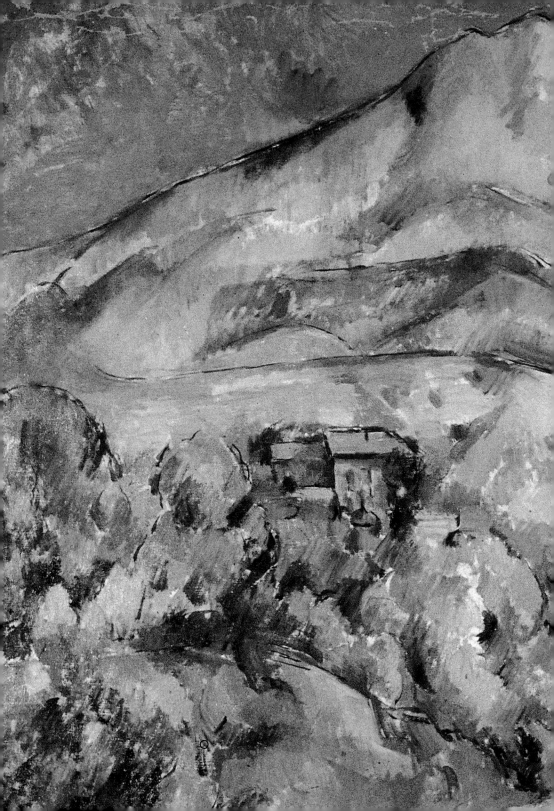

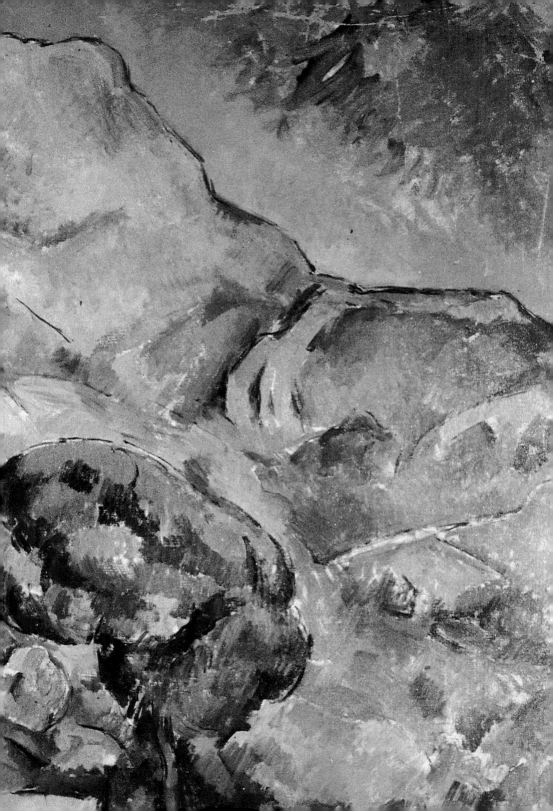

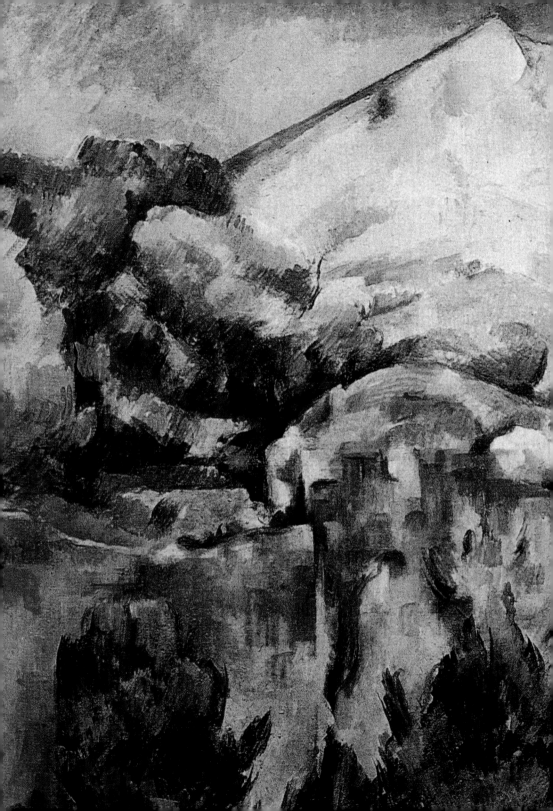

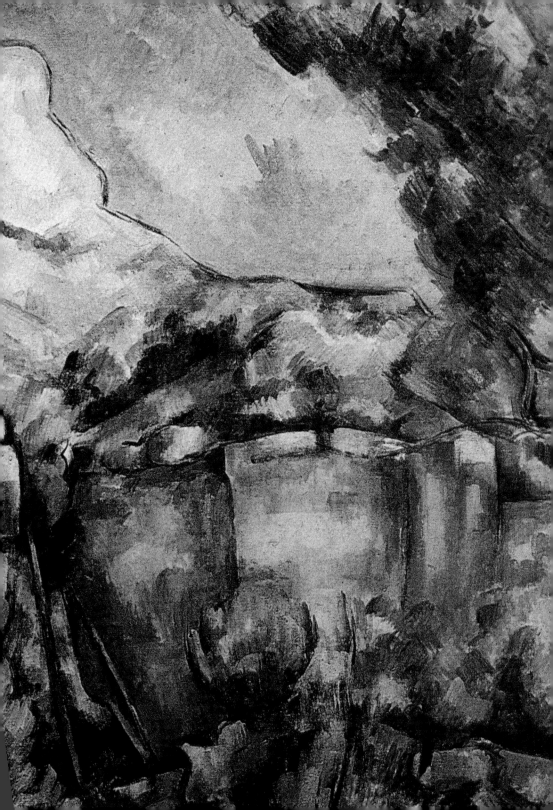

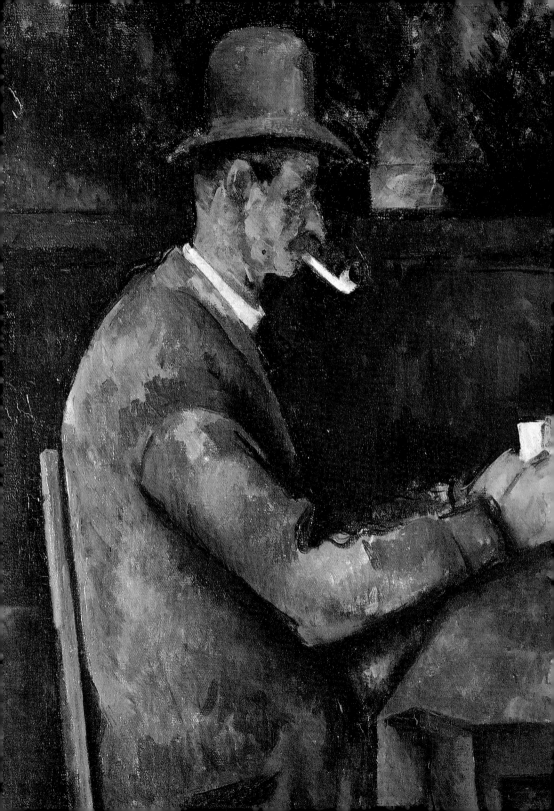

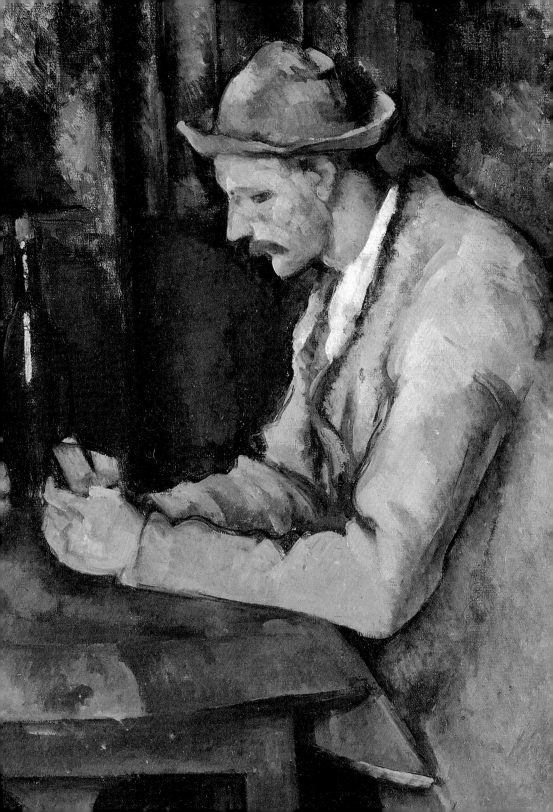

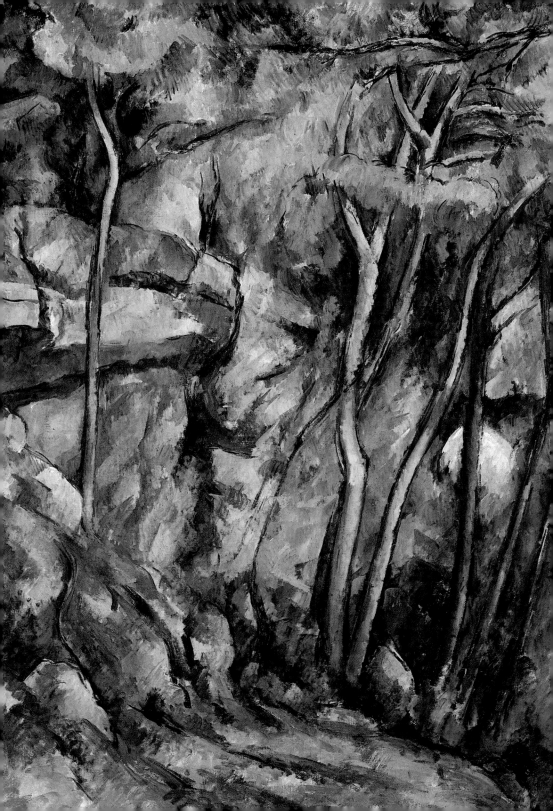

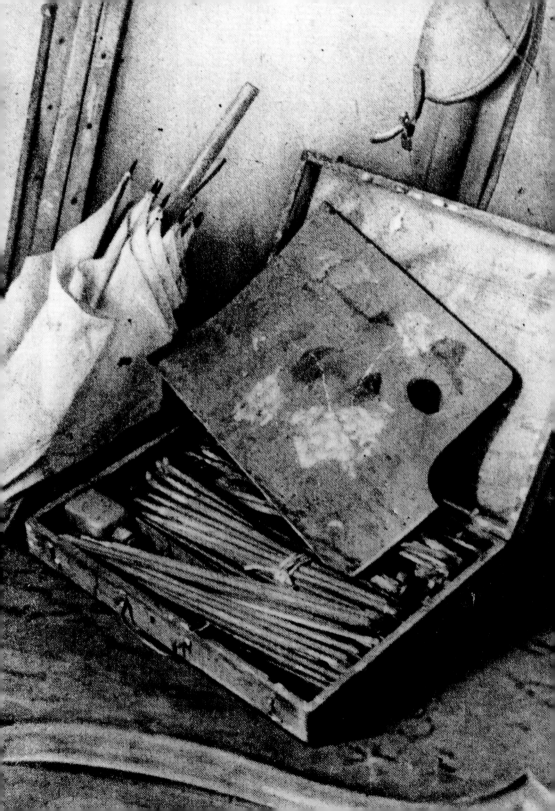

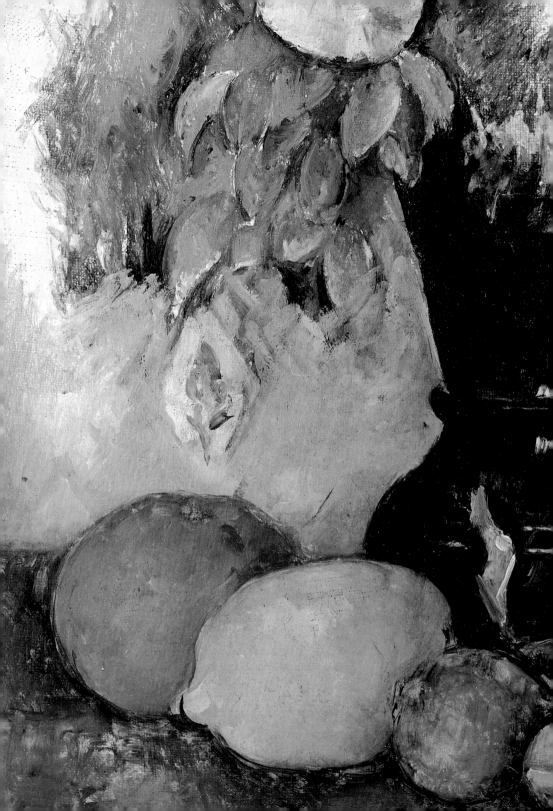

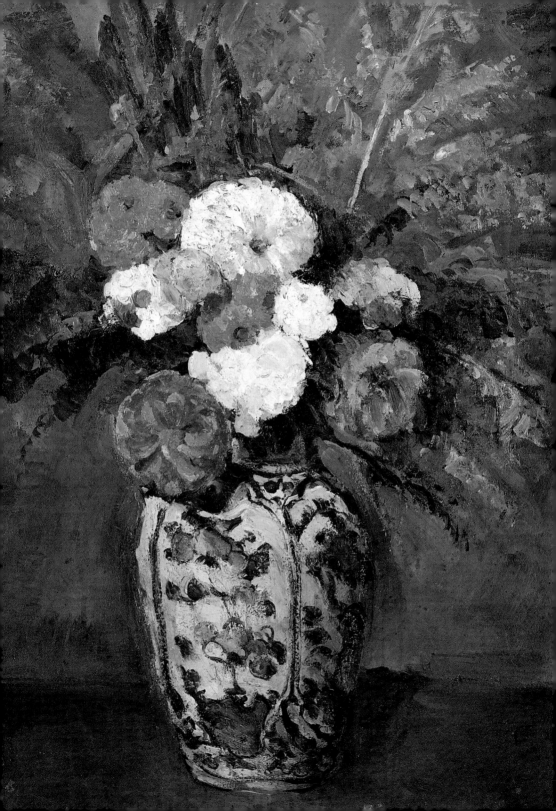

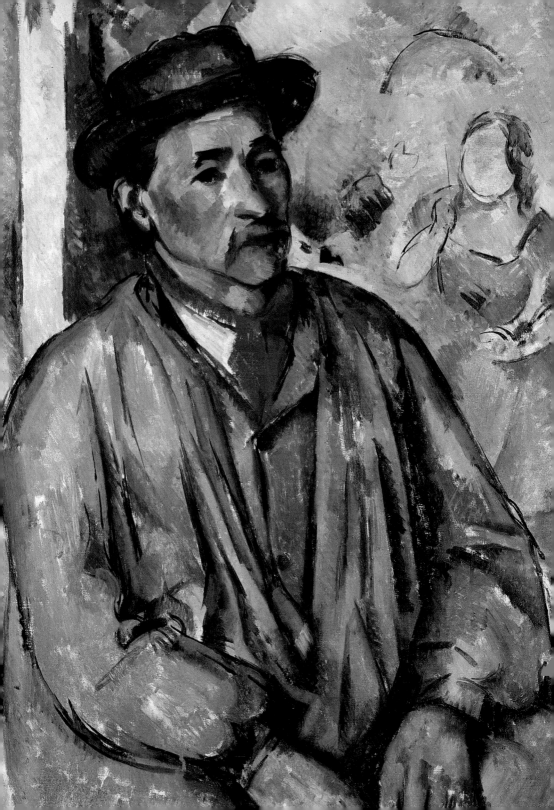

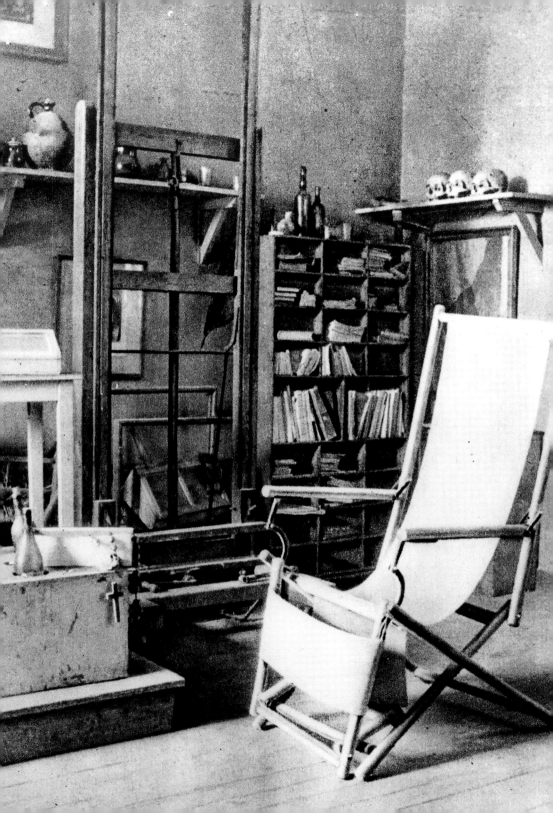

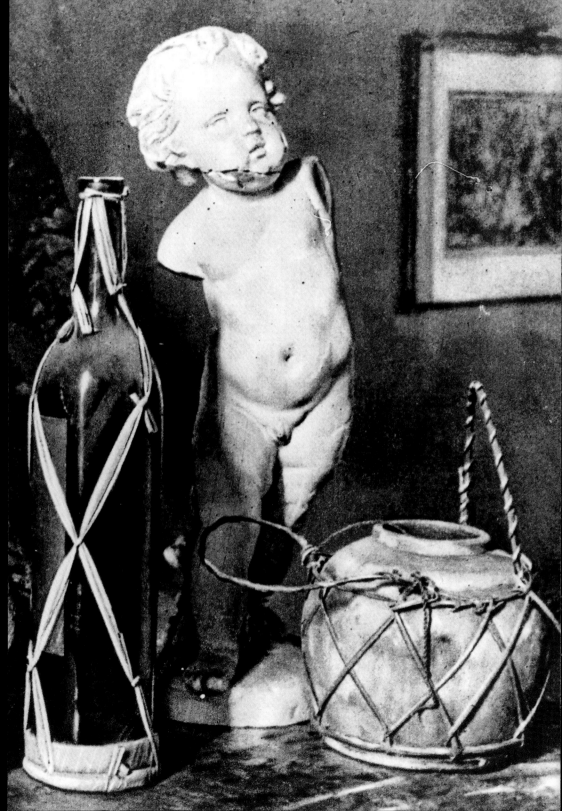

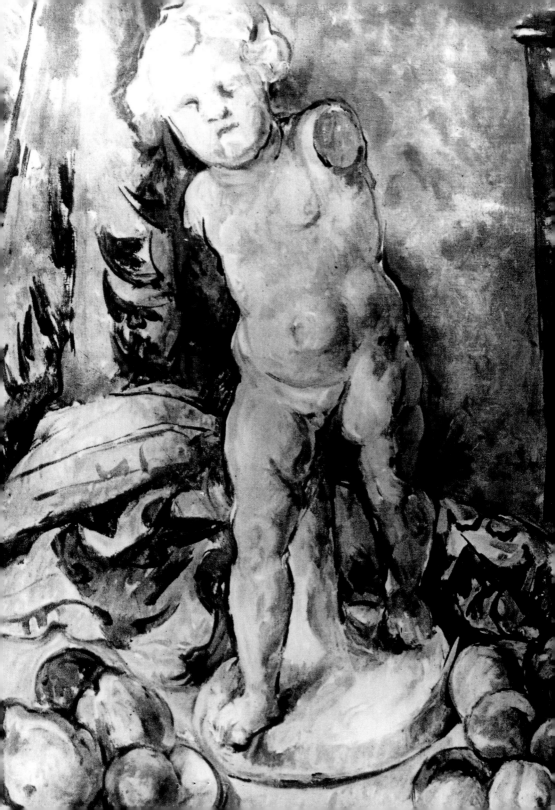

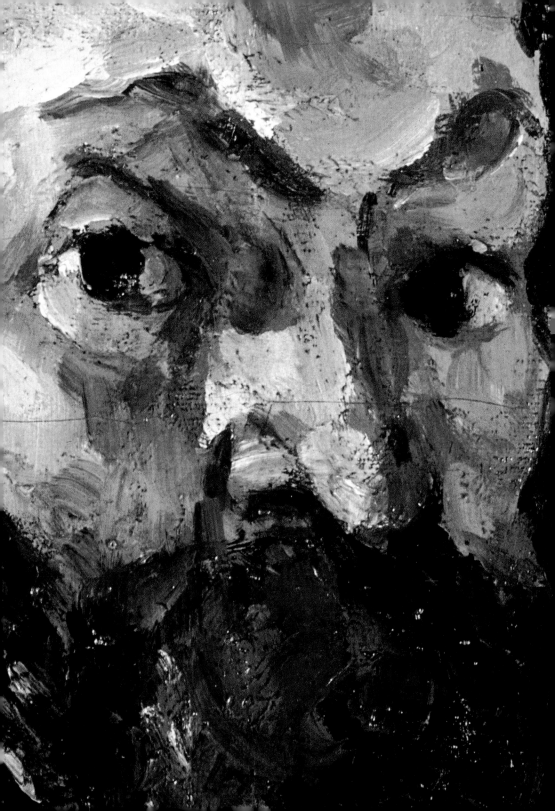

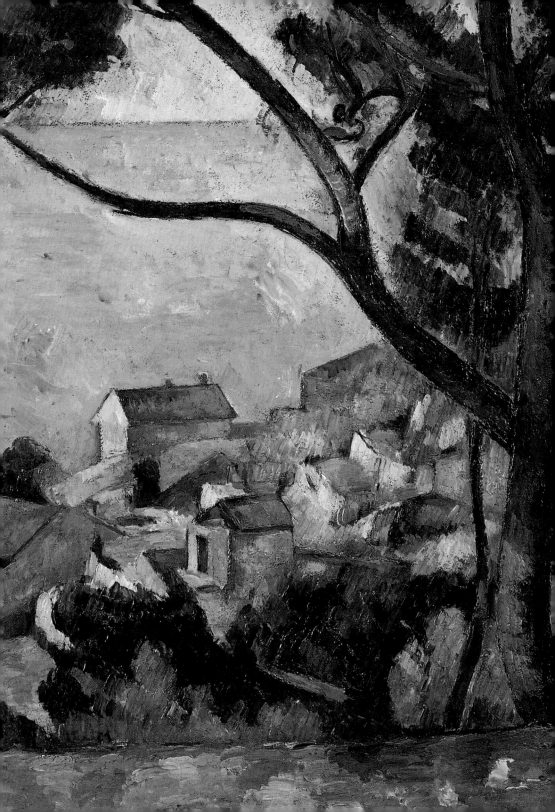

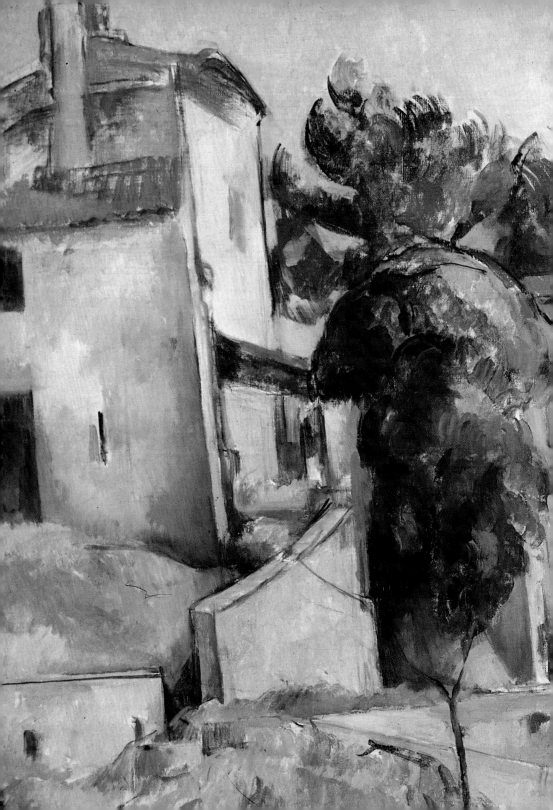

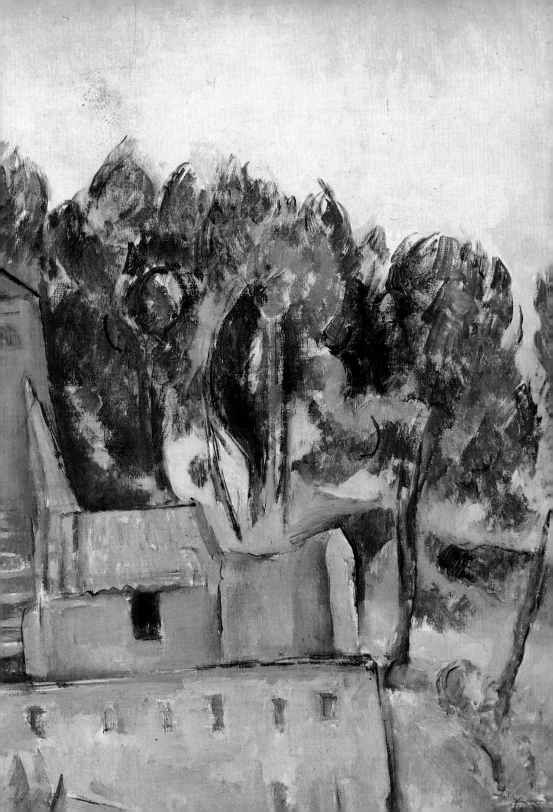

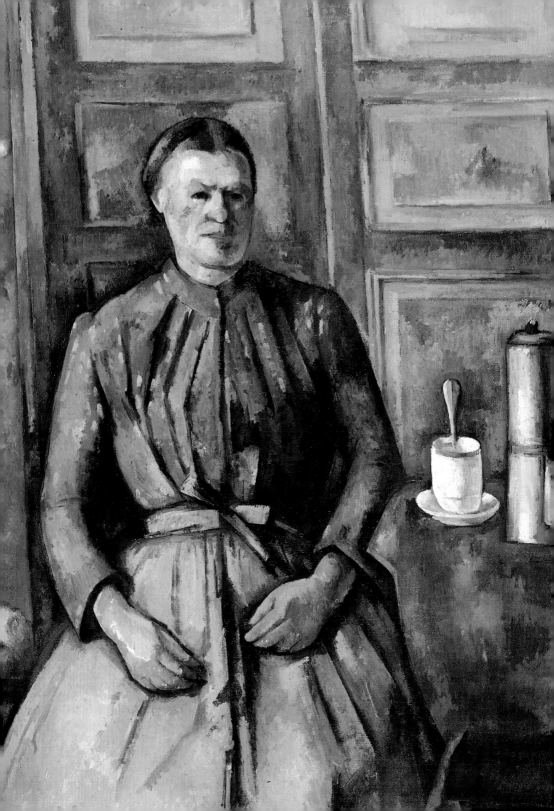

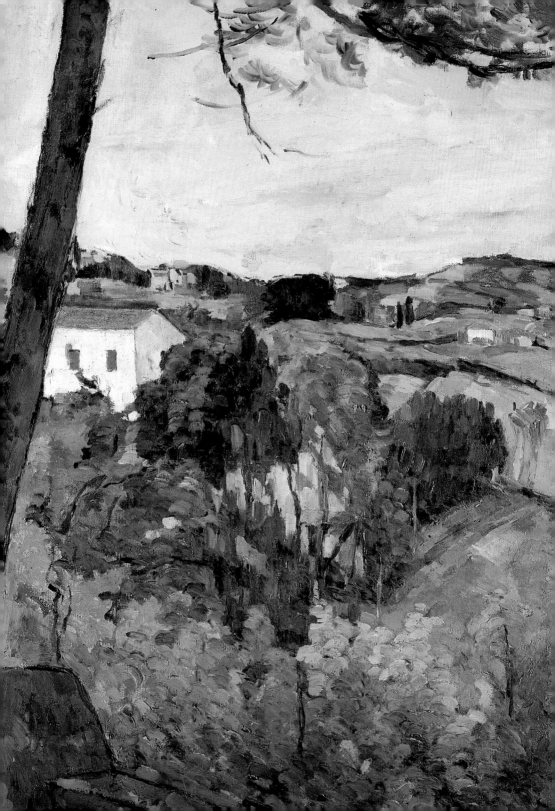

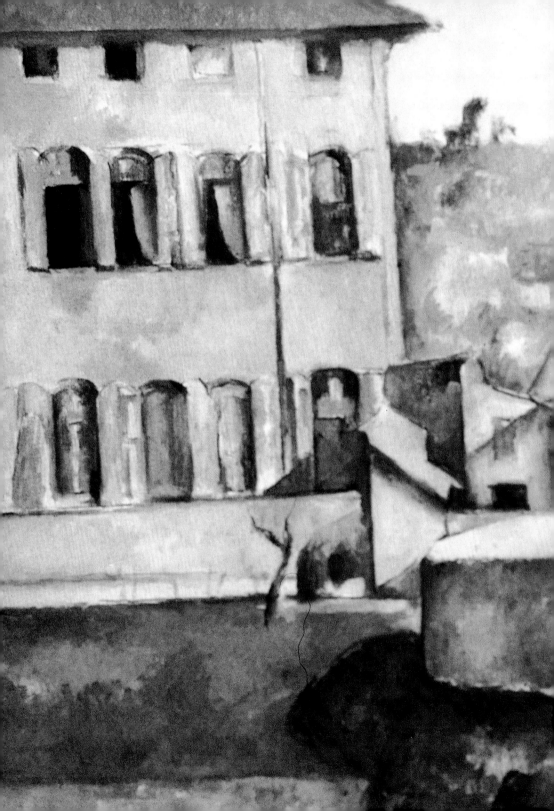

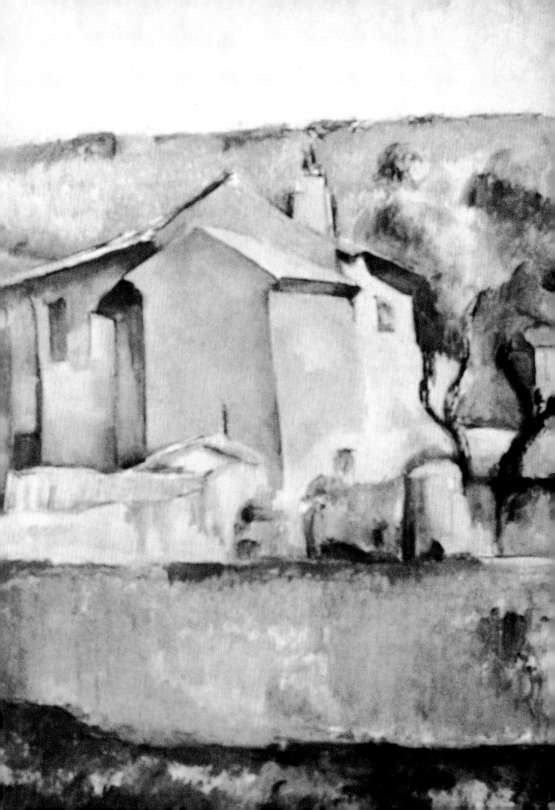

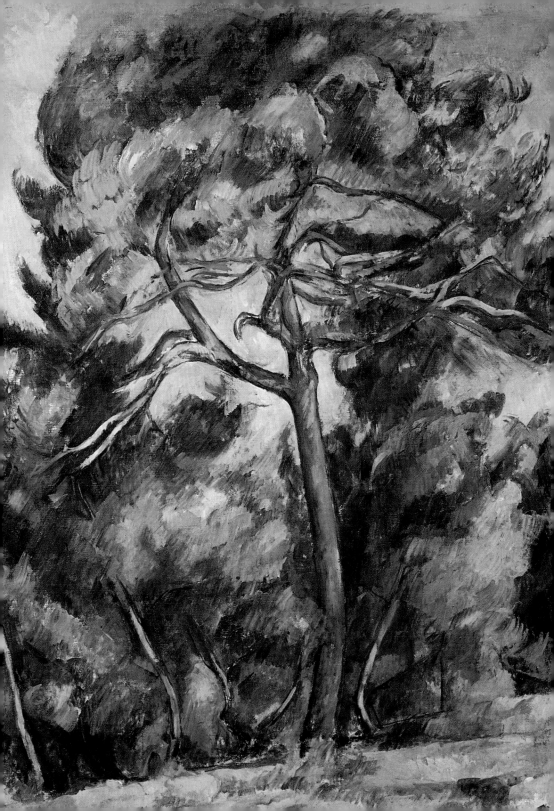

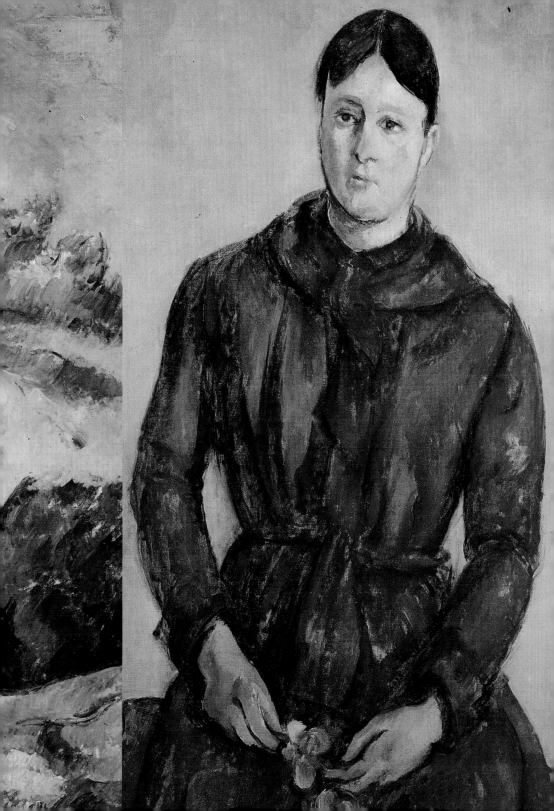

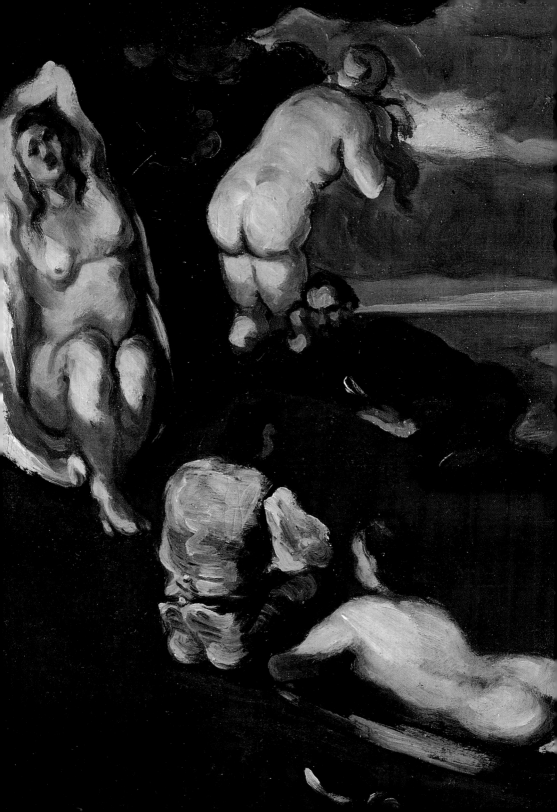

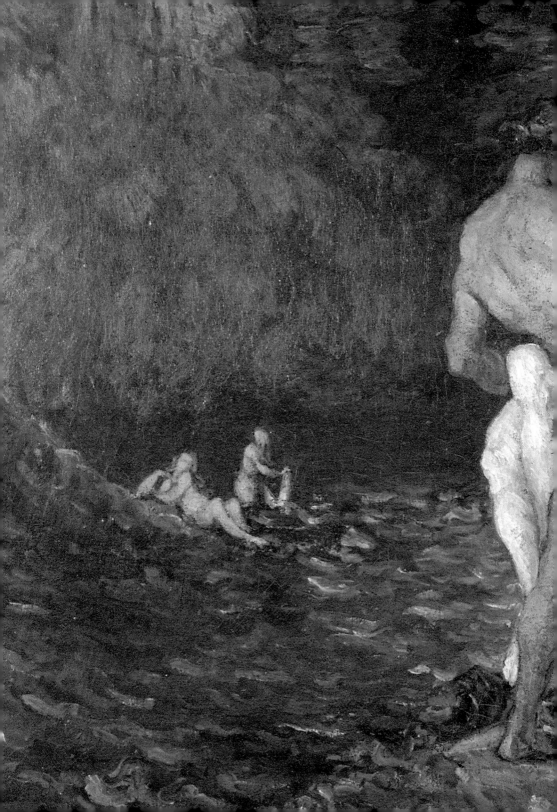

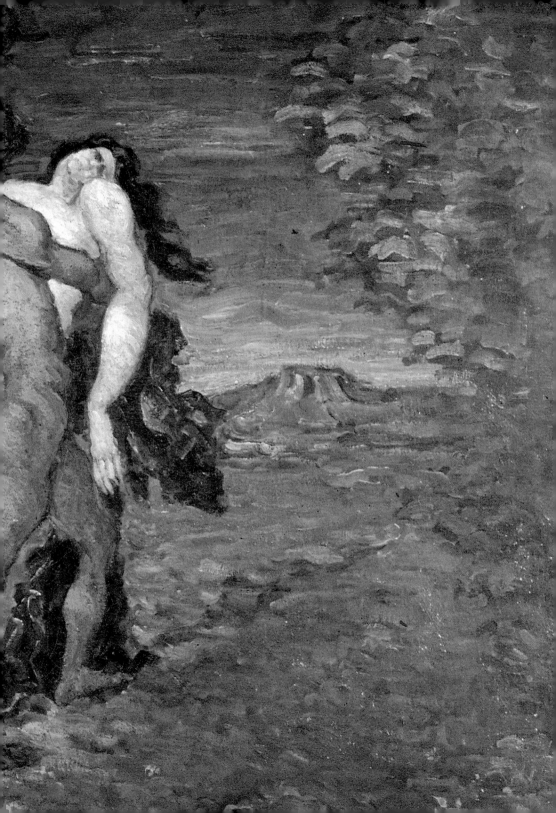

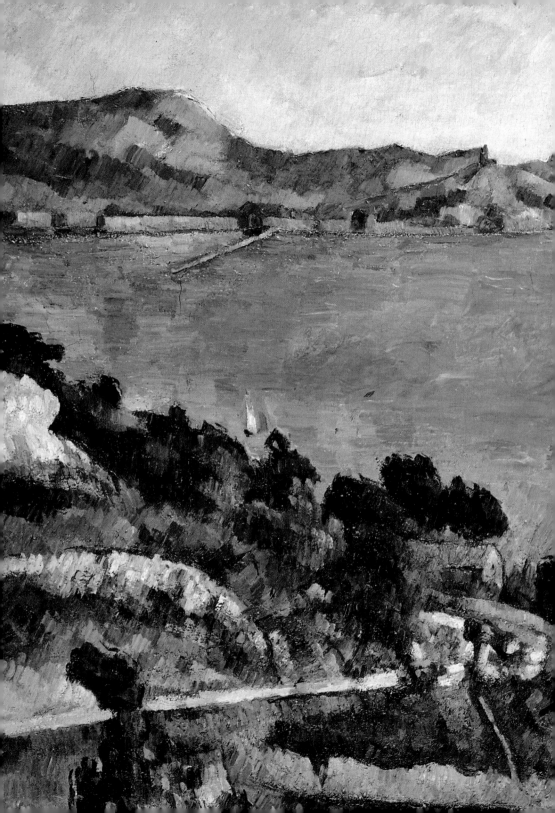

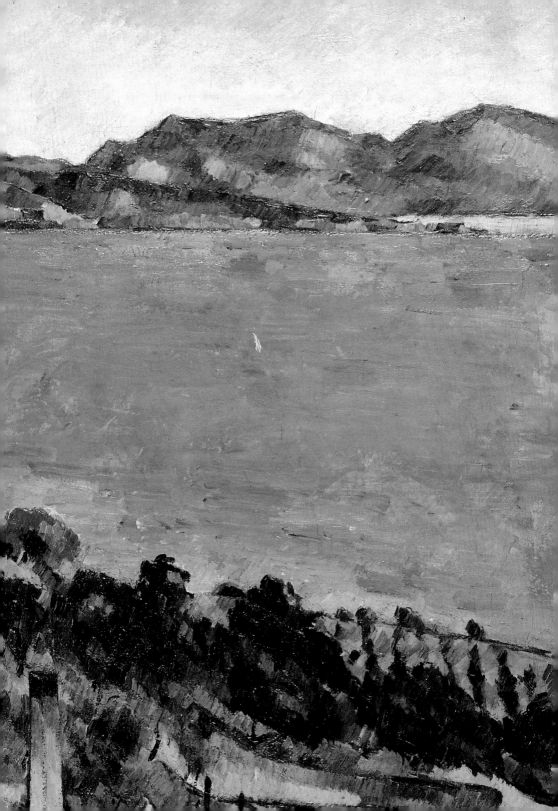

Cézanne in Provence

Turning Road in Provence, 1900-1906, Neue Pinakothek, Munich. Cézanne always loved roads, roads that turned and those that disappeared into the forest. Here, the liberated color and touch contrast with the rigor of the composition. Once again Cézanne achieved a precarious balance of order and disorder, movement and stability, color and drawing.
Paul Cézanne on the Chemin des Lauves, 1904. Photo Émile Bernard.

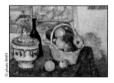

Still Life with Soup Tureen, 1877, Musée d'Orsay, Paris. In this painting Cézanne sought a well-integrated arrangement of fruit, objects, and décor. The paintings on the wall and the cloth on the table – all square or rectangular shapes – counterbalance the freer, cursive forms of apples, basket, and tureen.

Straw-cased Jar, Sugar Bowl, and Plate with Apples (detail), c. 1890-1894, Musée d'Orsay, Paris. The shifting perspectives adopted by Cézanne anticipated the innovations of Cubism. The perfectly modeled apple reflects the artist's long study of color and light, as well as the dramatic chiaroscuro of Provence.

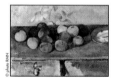

Apples and Biscuits, 1879-1882, Musée de l'Orangerie, Paris. The boy Émile Zola thanked his friend Paul Cézanne with a gift of apples for having defended him against a gang of school bullies. In the art of Cézanne, the apple evolved from a youthful memory into a motif open to tireless investigation. How, for instance, to represent an edgeless object with light flowing over its surface? How to "trace the boundaries of objects when the points of contact are tenuous and delicate"?

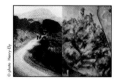

The road from Le Tholonet to Mont Sainte-Victoire, c. 1900. © Photo Henri-Ely. This is the vantage point Cézanne adopted for his views of Mont Sainte-Victoire. Photographer and painter chose the same motif, but in the painting the sequence of planes in depth is collapsed, allowing the mountain to invade and fill the canvas.
The Red Rock, c. 1895-1900, Musée de l'Orangerie, Paris. Caught in the grasp of a white boundary stone and a hewn cliff, the painting is fraught with tension.

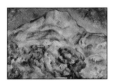

Mont Sainte-Victoire. Above the road of Le Tholonet, 1890-1900, Hermitage Museum, St. Petersburg. What a lot of obstacles Cézanne placed on the road between himself, or the viewer, and his sacred objective, the mountain! Progressively, in the course of his work, the artist approached his motif as if he were about to attain the absolute in painting.

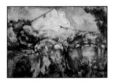

Mont Sainte-Victoire, Seen from Bibémus Quarry, c. 1900, Museum of Art, Baltimore. Cézanne, through frequent repetition, allied two themes: Bibémus and Mont Sainte-Victoire. The first derived from the old, abandoned quarries that had supplied the stone used in the construction of Aix-en-Provence. Sainte-Victoire evokes not only the mountain rising above Aix but also the Roman *Campagna* and thus the classical landscapes of Nicolas Poussin and Claude Lorrain.

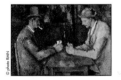

The Cardplayers, 1892-1893, Musée d'Orsay, Paris. "It's like playing cards. Red roofs against the blue sea," wrote Cézanne to Camille Pissarro on 2 July. Here, in a subject/form pun, painting approaches the flatness of a playing card even as the two confronted figures play at cards, in a game whose principal stake, for Cézanne, is painting itself.

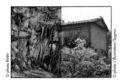

In the Park at Château-Noir, 1898, Musée de l'Orangerie, Paris. Cézanne loved the landscape around Aix, with its chaotic tangle of rocks, trees, and earth, its dramatically contrasted ochres, reds, yellows, and greens. But the picture is also powerfully structured, with trees that stabilize the rocks and prevent them from collapsing. Painting, therefore, keeps the world from falling apart.
Cézanne's studio behind the Church of Saint-Sauveur.

The Studio on the Chemin des Lauves with Cézanne's paint box. In this space, illuminated by large windows on the north and the south, Cézanne assembled only the objects and furniture absolutely essential to his work.
Flowers and Lemons, c. 1880, Musée de l'Orangerie, Paris. Here Cézanne roughed out a picture marked by contrasts of vivid, almost Fauve colors. The pictorial drama is evident in the sparkling fruit set off against the heavily impastoed grey around the flowers.

A souvenir of Cézanne: the artist's folding palette, on which the random assortment of colors suggests a bouquet of flowers.
Flowers in a Blue Vase, c. 1880, Musée d'Orsay, Paris. Flowers allowed Cézanne to carry his experiments with colors and values to the very threshold of abstraction. In this instance, the Aix master may very well have been painting with the bouquets of Manet in mind.

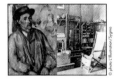

Peasant with a Blue Blouse, c. 1895-1900, Kimball Art Museum, Fort Worth. Cézanne had great affection for simple, quiet folk, posing them as pipe-smokers or cardplayers. With its mood of inner concentration, the painting seen here reflects Cézanne's long "meditation, with brush in hand." The subject seems at one with the artistic process through which it was realized.
The Interior of the painter's studio, furnished with books and the model's chair.

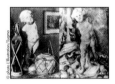

The plaster cast, bottle of rum, and straw-cased ceramic pot that Cézanne so often employed as motifs in his paintings.
Still Life with a Paster Cupid, 1895, National Museum, Stockholm. A great admirer of Pierre Puget, Cézanne always kept a plaster cast of the Cupid long attributed to the 17th-century French master. Cézanne, in his innate classicism, did not identify solely with Poussin but also with the Baroque drama captured by Puget.

Self-portrait (detail), 1873-1876, Musée d'Orsay, Paris. Rembrandt, in his auto-portraits, meditated upon the experience of growing old; Van Gogh recorded his terror of impending madness. Cézanne looked at himself and saw only "a painter yet to come".
The Sea at L'Estaque, 1883-1886, Musée Picasso, Paris. As painted by Cézanne; the scene comprises a full, opaque sea around which trees and houses cluster in a state of calm, ordered gravity.

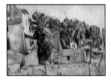

Bellevue Houses, 1890-1894, private collection, Geneva. From the Jas de Bouffan, Cézanne climbed Bellevue Hill where he painted the house depicted here. What attracted the artist was architectural complexity in rivalrous combination with the natural freedom of trees.

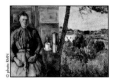

Woman with a Coffeepot, 1890-1895, Musée d'Orsay, Paris. In this painting Cézanne constructed the figure as a powerful, almost architectonic presence. Her rounded, relief-like forms play off against the flat, rectangular panels in the background. The monumental image faces the viewer with the immobility of a sculpture.
Pine Tree at L'Estaque, 1876, Musée d'Orsay, Paris. Cézanne has translated his earlier pugnacity into bold compositions and daring colors, such as a sharp saturated green.

House and Farm at the Jas de Bouffan (detail), c. 1885, Narodní Gallery, Prague. Louis-Auguste Cézanne, the artist's father, acquired the Jas de Bouffan in 1859. Paul returned there so often the house became the very symbol of his residence in Provence. The farm, as represented here, anticipated the proto-Cubist contrasts of Cézanne's middle and late work.

The Great Pine, 1892-1896, Museum of Art, São Paulo. The Aleppo pine, which Cézanne loved, spreads its limbs in every direction, balancing them on all sides, and, despite the heat and wind, it remains solidly planted in the soil of Provence. **Madame Cézanne in Red,** 1888-90, Museum of Art, São Paulo. Mme Cézanne could pose as still as an apple. Although the face is a psychological void, the violet-red dress activates the entire canvas and invests the figure with weight and power.

Château-Noir, 1904-1906, Musée Picasso, Paris. This painting, with its strong verticals and horizontals, displays something of the compositional rigor that would emerge in the mature work of Piet Mondrian. Meanwhile, the ogival window is at one with the wild, tumultuous forest that encroaches from every side. The drama of this conflict is played out in the strongly contrasted ochres and greens, a contrast the painter struggled to control.

Pastorale, c. 1870, Musée d'Orsay, Paris. The lonely and frustrated Cézanne sought relief in this strange Venusberg, a theme inspired by Wagner's *Tannhäuser*. The three women flaunt their voluptuous breasts and thighs, which the painter attempts to resist by turning away. The pipe-smoking fisherman on the right may signify Zola. Already, however, compositional rigor has begun to assert itself, with vertical and horizontal lines stabilizing the whirlwind assortment of female nudes.

The Abduction, 1867, Museum of Fine Arts, Liverpool. Metaphorically, the "young Cézanne" struggles to bear the weight of painting, symbolized by a swooning nude whose body the artist attempts to bear all the way to Mont Sainte-Victoire on the far horizon. The heavily impastoed surface reflects a romantic, stormy spirit in search of equilibrium.

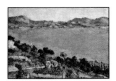

The Gulf of Marseilles Seen from L'Estaque, 1878-1879, Musée d'Orsay, Paris. A sea, a serene impasto, very blue and very thick. The Mediterranean, as painted by Cézanne, is not the English Channel. "A magnificent southern marine" is how Gustave Geoffroy characterized the painting in 1897.